MicNic Editions

MY MOVIE LOGBOOK

Mickaël Nicotera

This book belongs to

..................................

MOVIE TITLE :

..

Director :	Seen for the first time on the :
....................................

Duration : h min

Genre :

- ☐ Animation
- ☐ Adventure
- ☐ Mystery
- ☐ Heroïc fantasy
- ☐ Comedy
- ☐ Action
- ☐ War
- ☐ Science fiction
- ☐ Horror
- ☐ Thriller
- ☐ Drama
- ☐ Epics / Historical
- ☐ Disaster
- ☐ Romance
- ☐ Other :

Seen :

- ☐ on TV
- ☐ in a theatre
- ☐ on DVD
- ☐ on bluray
- ☐ on VOD
- ☐ in a place

Star n°1 :

....................................

Star n°2 :

....................................

Music by :

....................................

Movie released on :

....................................

Studio :

....................................

Gauges :

Action Humor Emotion Thrill

Enjoyment :

☆ ☆ ☆ ☆ ☆

Stick here your movie ticket or the synopsis you have printed or cut in a TV magazine :

My favorite scene :

..

..

..

..

..

..

My favorite replica :

..

..

..

..

..

..

Rating :

☐ G (General Audiences)
☐ PG (Parental Guidance Suggested)
☐ PG-13 (Parents Strongly Cautioned)
☐ R (Restricted)
☐ NC-17 (No One 17 and under admitted)

Number of times you have watched the movie :

☐ ☐ ☐ ☐ ☐ ☐ ☐ ☐ ☐

☐ ☐ ☐ ☐ ☐ ☐ ☐ ☐ ☐

MOVIE TITLE :

..

Director :	Seen for the first time on the :
..	..

Duration : h min	Star n°1 :
Genre :	..
	Star n°2 :
☐ Animation	
☐ Adventure	..
☐ Mystery	Music by :
☐ Heroïc fantasy	
☐ Comedy	..
☐ Action	Movie released on :
☐ War	
☐ Science fiction	..
☐ Horror	Studio :
☐ Thriller	
☐ Drama	..
☐ Epics / Historical	Gauges :
☐ Disaster	
☐ Romance	Action Humor Emotion Thrill
☐ Other :	
Seen :	
☐ on TV	
☐ in a theatre	
☐ on DVD	Enjoyment :
☐ on bluray	
☐ on VOD	☆ ☆ ☆ ☆ ☆
☐ in a place	

Stick here your movie ticket or the synopsis you have printed or cut in a TV magazine :

My favorite scene :

..
..
..
..
..
..

My favorite replica :

..
..
..
..
..
..

Rating :

☐ G (General Audiences)
☐ PG (Parental Guidance Suggested)
☐ PG-13 (Parents Strongly Cautioned)
☐ R (Restricted)
☐ NC-17 (No One 17 and under admitted)

Number of times you have watched the movie :

☐ ☐ ☐ ☐ ☐ ☐ ☐ ☐ ☐

☐ ☐ ☐ ☐ ☐ ☐ ☐ ☐ ☐

MOVIE TITLE :

..

Director :	Seen for the first time on the :
..	..

Duration : h min

Genre :

- ☐ Animation
- ☐ Adventure
- ☐ Mystery
- ☐ Heroïc fantasy
- ☐ Comedy
- ☐ Action
- ☐ War
- ☐ Science fiction
- ☐ Horror
- ☐ Thriller
- ☐ Drama
- ☐ Epics / Historical
- ☐ Disaster
- ☐ Romance
- ☐ Other :

Seen :

- ☐ on TV
- ☐ in a theatre
- ☐ on DVD
- ☐ on bluray
- ☐ on VOD
- ☐ in a place

Star n°1 :

..

Star n°2 :

..

Music by :

..

Movie released on :

..

Studio :

..

Gauges :

Action Humor Emotion Thrill

Enjoyment :

☆ ☆ ☆ ☆ ☆

Stick here your movie ticket or the synopsis you have printed or cut in a TV magazine :

My favorite scene :

..
..
..
..
..
..

My favorite replica :

..
..
..
..
..
..

Rating :

☐ G (General Audiences)
☐ PG (Parental Guidance Suggested)
☐ PG-13 (Parents Strongly Cautioned)
☐ R (Restricted)
☐ NC-17 (No One 17 and under admitted)

Number of times you have watched the movie :

☐ ☐ ☐ ☐ ☐ ☐ ☐ ☐ ☐ ☐
☐ ☐ ☐ ☐ ☐ ☐ ☐ ☐ ☐ ☐

MOVIE TITLE :

..

Director :	Seen for the first time on the :
..	..

Duration : h min

Genre :

- ☐ Animation
- ☐ Adventure
- ☐ Mystery
- ☐ Heroïc fantasy
- ☐ Comedy
- ☐ Action
- ☐ War
- ☐ Science fiction
- ☐ Horror
- ☐ Thriller
- ☐ Drama
- ☐ Epics / Historical
- ☐ Disaster
- ☐ Romance
- ☐ Other :

Seen :

- ☐ on TV
- ☐ in a theatre
- ☐ on DVD
- ☐ on bluray
- ☐ on VOD
- ☐ in a place

Star n°1 :

..

Star n°2 :

..

Music by :

..

Movie released on :

..

Studio :

..

Gauges :

Action Humor Emotion Thrill

Enjoyment :

☆ ☆ ☆ ☆ ☆

Stick here your movie ticket or the synopsis you have printed or cut in a TV magazine :

My favorite scene :

..
..
..
..
..
..

My favorite replica :

..
..
..
..
..
..

Rating :

☐ G (General Audiences)
☐ PG (Parental Guidance Suggested)
☐ PG-13 (Parents Strongly Cautioned)
☐ R (Restricted)
☐ NC-17 (No One 17 and under admitted)

Number of times you have watched the movie :

☐☐☐☐☐☐☐☐☐

☐☐☐☐☐☐☐☐☐

MOVIE TITLE :

..

Director :	Seen for the first time on the :
..	..

Duration : h min

Genre :

- ☐ Animation
- ☐ Adventure
- ☐ Mystery
- ☐ Heroïc fantasy
- ☐ Comedy
- ☐ Action
- ☐ War
- ☐ Science fiction
- ☐ Horror
- ☐ Thriller
- ☐ Drama
- ☐ Epics / Historical
- ☐ Disaster
- ☐ Romance
- ☐ Other :

Seen :

- ☐ on TV
- ☐ in a theatre
- ☐ on DVD
- ☐ on bluray
- ☐ on VOD
- ☐ in a place

Star n°1 :

..

Star n°2 :

..

Music by :

..

Movie released on :

..

Studio :

..

Gauges :

Action Humor Emotion Thrill

Enjoyment :

☆ ☆ ☆ ☆ ☆

Stick here your movie ticket or the synopsis you have printed or cut in a TV magazine :

My favorite scene :

..
..
..
..
..
..

My favorite replica :

..
..
..
..
..
..

Rating :

☐ G (General Audiences)
☐ PG (Parental Guidance Suggested)
☐ PG-13 (Parents Strongly Cautioned)
☐ R (Restricted)
☐ NC-17 (No One 17 and under admitted)

Number of times you have watched the movie :

☐☐☐☐☐☐☐☐☐

☐☐☐☐☐☐☐☐☐

MOVIE TITLE :

..

Director :	Seen for the first time on the :
..	..

Duration : h min

Genre :

- ☐ Animation
- ☐ Adventure
- ☐ Mystery
- ☐ Heroïc fantasy
- ☐ Comedy
- ☐ Action
- ☐ War
- ☐ Science fiction
- ☐ Horror
- ☐ Thriller
- ☐ Drama
- ☐ Epics / Historical
- ☐ Disaster
- ☐ Romance
- ☐ Other : ..

Seen :

- ☐ on TV
- ☐ in a theatre
- ☐ on DVD
- ☐ on bluray
- ☐ on VOD
- ☐ in a place

Star n°1 :

..

Star n°2 :

..

Music by :

..

Movie released on :

..

Studio :

..

Gauges :

Action Humor Emotion Thrill

Enjoyment :

☆ ☆ ☆ ☆ ☆

14

Stick here your movie ticket or the synopsis you have printed or cut in a TV magazine :

My favorite scene :

..

..

..

..

..

..

My favorite replica :

..

..

..

..

..

..

Rating :

☐ G (General Audiences)
☐ PG (Parental Guidance Suggested)
☐ PG-13 (Parents Strongly Cautioned)
☐ R (Restricted)
☐ NC-17 (No One 17 and under admitted)

Number of times you have watched the movie :

☐ ☐ ☐ ☐ ☐ ☐ ☐ ☐ ☐

☐ ☐ ☐ ☐ ☐ ☐ ☐ ☐ ☐

MOVIE TITLE :

..

Director :	Seen for the first time on the :
..	..

Duration : h min Genre : ☐ Animation ☐ Adventure ☐ Mystery ☐ Heroïc fantasy ☐ Comedy ☐ Action ☐ War ☐ Science fiction ☐ Horror ☐ Thriller ☐ Drama ☐ Epics / Historical ☐ Disaster ☐ Romance ☐ Other : .. Seen : ☐ on TV ☐ in a theatre ☐ on DVD ☐ on bluray ☐ on VOD ☐ in a place	Star n°1 : .. Star n°2 : .. Music by : .. Movie released on : .. Studio : .. Gauges : Action Humor Emotion Thrill Enjoyment : ☆ ☆ ☆ ☆ ☆

Stick here your movie ticket or the synopsis you have printed or cut in a TV magazine :

My favorite scene :

..

..

..

..

..

..

My favorite replica :

..

..

..

..

..

..

Rating :

☐ G (General Audiences)
☐ PG (Parental Guidance Suggested)
☐ PG-13 (Parents Strongly Cautioned)
☐ R (Restricted)
☐ NC-17 (No One 17 and under admitted)

Number of times you have watched the movie :

☐ ☐ ☐ ☐ ☐ ☐ ☐ ☐ ☐

☐ ☐ ☐ ☐ ☐ ☐ ☐ ☐ ☐

MOVIE TITLE :

..

Director :	Seen for the first time on the :
..	..

Duration : h min

Genre :

- ☐ Animation
- ☐ Adventure
- ☐ Mystery
- ☐ Heroïc fantasy
- ☐ Comedy
- ☐ Action
- ☐ War
- ☐ Science fiction
- ☐ Horror
- ☐ Thriller
- ☐ Drama
- ☐ Epics / Historical
- ☐ Disaster
- ☐ Romance
- ☐ Other :

Seen :

- ☐ on TV
- ☐ in a theatre
- ☐ on DVD
- ☐ on bluray
- ☐ on VOD
- ☐ in a place

Star n°1 :

..

Star n°2 :

..

Music by :

..

Movie released on :

..

Studio :

..

Gauges :

Action Humor Emotion Thrill

Enjoyment :

☆ ☆ ☆ ☆ ☆

Stick here your movie ticket or the synopsis you have printed or cut in a TV magazine :

My favorite scene :

..

..

..

..

..

..

My favorite replica :

..

..

..

..

..

..

Rating :

☐ G (General Audiences)
☐ PG (Parental Guidance Suggested)
☐ PG-13 (Parents Strongly Cautioned)
☐ R (Restricted)
☐ NC-17 (No One 17 and under admitted)

Number of times you have watched the movie :

☐ ☐ ☐ ☐ ☐ ☐ ☐ ☐ ☐

☐ ☐ ☐ ☐ ☐ ☐ ☐ ☐ ☐

MOVIE TITLE :

..

Director :	Seen for the first time on the :
..	..

Duration : h min

Genre :

- ☐ Animation
- ☐ Adventure
- ☐ Mystery
- ☐ Heroïc fantasy
- ☐ Comedy
- ☐ Action
- ☐ War
- ☐ Science fiction
- ☐ Horror
- ☐ Thriller
- ☐ Drama
- ☐ Epics / Historical
- ☐ Disaster
- ☐ Romance
- ☐ Other : ..

Seen :

- ☐ on TV
- ☐ in a theatre
- ☐ on DVD
- ☐ on bluray
- ☐ on VOD
- ☐ in a place

Star n°1 :

..

Star n°2 :

..

Music by :

..

Movie released on :

..

Studio :

..

Gauges :

Action Humor Emotion Thrill

Enjoyment :

☆ ☆ ☆ ☆ ☆

Stick here your movie ticket or the synopsis you have printed or cut in a TV magazine :

My favorite scene :

..

..

..

..

..

..

My favorite replica :

..

..

..

..

..

..

Rating :

☐ G (General Audiences)
☐ PG (Parental Guidance Suggested)
☐ PG-13 (Parents Strongly Cautioned)
☐ R (Restricted)
☐ NC-17 (No One 17 and under admitted)

Number of times you have watched the movie :

☐ ☐ ☐ ☐ ☐ ☐ ☐ ☐ ☐

☐ ☐ ☐ ☐ ☐ ☐ ☐ ☐ ☐

MOVIE TITLE :

..

Director :	Seen for the first time on the :
..	..

Duration : h min

Genre :

☐ Animation
☐ Adventure
☐ Mystery
☐ Heroïc fantasy
☐ Comedy
☐ Action
☐ War
☐ Science fiction
☐ Horror
☐ Thriller
☐ Drama
☐ Epics / Historical
☐ Disaster
☐ Romance
☐ Other :

Seen :

☐ on TV
☐ in a theatre
☐ on DVD
☐ on bluray
☐ on VOD
☐ in a place

Star n°1 :
..
Star n°2 :
..
Music by :
..
Movie released on :
..
Studio :
..

Gauges :

Action Humor Emotion Thrill

Enjoyment :

☆ ☆ ☆ ☆ ☆

Stick here your movie ticket or the synopsis you have printed or cut in a TV magazine :

My favorite scene :

..

..

..

..

..

..

My favorite replica :

..

..

..

..

..

..

Rating :

☐ G (General Audiences)
☐ PG (Parental Guidance Suggested)
☐ PG-13 (Parents Strongly Cautioned)
☐ R (Restricted)
☐ NC-17 (No One 17 and under admitted)

Number of times you have watched the movie :

☐ ☐ ☐ ☐ ☐ ☐ ☐ ☐ ☐

☐ ☐ ☐ ☐ ☐ ☐ ☐ ☐ ☐

MOVIE TITLE :

..

Director :	Seen for the first time on the :
..	..

Duration : h min

Genre :

- ☐ Animation
- ☐ Adventure
- ☐ Mystery
- ☐ Heroïc fantasy
- ☐ Comedy
- ☐ Action
- ☐ War
- ☐ Science fiction
- ☐ Horror
- ☐ Thriller
- ☐ Drama
- ☐ Epics / Historical
- ☐ Disaster
- ☐ Romance
- ☐ Other : ..

Seen :

- ☐ on TV
- ☐ in a theatre
- ☐ on DVD
- ☐ on bluray
- ☐ on VOD
- ☐ in a place

Star n°1 :

..

Star n°2 :

..

Music by :

..

Movie released on :

..

Studio :

..

Gauges :

Action Humor Emotion Thrill

Enjoyment :

☆ ☆ ☆ ☆ ☆

Stick here your movie ticket or the synopsis you have printed or cut in a TV magazine :

My favorite scene :

..
..
..
..
..
..

My favorite replica :

..
..
..
..
..
..

Rating :

☐ G (General Audiences)
☐ PG (Parental Guidance Suggested)
☐ PG-13 (Parents Strongly Cautioned)
☐ R (Restricted)
☐ NC-17 (No One 17 and under admitted)

Number of times you have watched the movie :

☐☐☐☐☐☐☐☐☐

☐☐☐☐☐☐☐☐☐

MOVIE TITLE :

..

Director :	Seen for the first time on the :
..	..

Duration : h min

Genre :

- ☐ Animation
- ☐ Adventure
- ☐ Mystery
- ☐ Heroïc fantasy
- ☐ Comedy
- ☐ Action
- ☐ War
- ☐ Science fiction
- ☐ Horror
- ☐ Thriller
- ☐ Drama
- ☐ Epics / Historical
- ☐ Disaster
- ☐ Romance
- ☐ Other :

Seen :

- ☐ on TV
- ☐ in a theatre
- ☐ on DVD
- ☐ on bluray
- ☐ on VOD
- ☐ in a place

Star n°1 :

..

Star n°2 :

..

Music by :

..

Movie released on :

..

Studio :

..

Gauges :

Action Humor Emotion Thrill

Enjoyment :

☆ ☆ ☆ ☆ ☆

Stick here your movie ticket or the synopsis you have printed or cut in a TV magazine :

My favorite scene :

..

..

..

..

..

..

My favorite replica :

..

..

..

..

..

..

Rating :

☐ G (General Audiences)
☐ PG (Parental Guidance Suggested)
☐ PG-13 (Parents Strongly Cautioned)
☐ R (Restricted)
☐ NC-17 (No One 17 and under admitted)

Number of times you have watched the movie :

☐ ☐ ☐ ☐ ☐ ☐ ☐ ☐ ☐

☐ ☐ ☐ ☐ ☐ ☐ ☐ ☐ ☐

MOVIE TITLE :

..

Director :	Seen for the first time on the :
..	..

Duration : h min

Genre :

- ☐ Animation
- ☐ Adventure
- ☐ Mystery
- ☐ Heroïc fantasy
- ☐ Comedy
- ☐ Action
- ☐ War
- ☐ Science fiction
- ☐ Horror
- ☐ Thriller
- ☐ Drama
- ☐ Epics / Historical
- ☐ Disaster
- ☐ Romance
- ☐ Other :

Seen :

- ☐ on TV
- ☐ in a theatre
- ☐ on DVD
- ☐ on bluray
- ☐ on VOD
- ☐ in a place

Star n°1 :

..

Star n°2 :

..

Music by :

..

Movie released on :

..

Studio :

..

Gauges :

Action Humor Emotion Thrill

Enjoyment :

☆ ☆ ☆ ☆ ☆

Stick here your movie ticket or the synopsis you have printed or cut in a TV magazine :

My favorite scene :

..

..

..

..

..

..

My favorite replica :

..

..

..

..

..

..

Rating :

☐ G (General Audiences)
☐ PG (Parental Guidance Suggested)
☐ PG-13 (Parents Strongly Cautioned)
☐ R (Restricted)
☐ NC-17 (No One 17 and under admitted)

Number of times you have watched the movie :

☐ ☐ ☐ ☐ ☐ ☐ ☐ ☐ ☐

☐ ☐ ☐ ☐ ☐ ☐ ☐ ☐ ☐

MOVIE TITLE :

..

Director :	Seen for the first time on the :
..	..

Duration : h min

Genre :

- ☐ Animation
- ☐ Adventure
- ☐ Mystery
- ☐ Heroïc fantasy
- ☐ Comedy
- ☐ Action
- ☐ War
- ☐ Science fiction
- ☐ Horror
- ☐ Thriller
- ☐ Drama
- ☐ Epics / Historical
- ☐ Disaster
- ☐ Romance
- ☐ Other : ...

Seen :

- ☐ on TV
- ☐ in a theatre
- ☐ on DVD
- ☐ on bluray
- ☐ on VOD
- ☐ in a place

Star n°1 :

..

Star n°2 :

..

Music by :

..

Movie released on :

..

Studio :

..

Gauges :

Action Humor Emotion Thrill

Enjoyment :

☆ ☆ ☆ ☆ ☆

30

Stick here your movie ticket or the synopsis you have printed or cut in a TV magazine :

My favorite scene :

..

..

..

..

..

..

My favorite replica :

..

..

..

..

..

..

Rating :

☐ G (General Audiences)
☐ PG (Parental Guidance Suggested)
☐ PG-13 (Parents Strongly Cautioned)
☐ R (Restricted)
☐ NC-17 (No One 17 and under admitted)

Number of times you have watched the movie :

☐☐☐☐☐☐☐☐☐

☐☐☐☐☐☐☐☐☐

MOVIE TITLE :

..

Director :	Seen for the first time on the :
..	..

Duration : h min

Genre :

- ☐ Animation
- ☐ Adventure
- ☐ Mystery
- ☐ Heroïc fantasy
- ☐ Comedy
- ☐ Action
- ☐ War
- ☐ Science fiction
- ☐ Horror
- ☐ Thriller
- ☐ Drama
- ☐ Epics / Historical
- ☐ Disaster
- ☐ Romance
- ☐ Other :

Seen :

- ☐ on TV
- ☐ in a theatre
- ☐ on DVD
- ☐ on bluray
- ☐ on VOD
- ☐ in a place

Star n°1 :

..

Star n°2 :

..

Music by :

..

Movie released on :

..

Studio :

..

Gauges :

Action	Humor	Emotion	Thrill

Enjoyment :

☆ ☆ ☆ ☆ ☆

Stick here your movie ticket or the synopsis you have printed or cut in a TV magazine :

My favorite scene :

..

..

..

..

..

..

My favorite replica :

..

..

..

..

..

..

Rating :

☐ G (General Audiences)
☐ PG (Parental Guidance Suggested)
☐ PG-13 (Parents Strongly Cautioned)
☐ R (Restricted)
☐ NC-17 (No One 17 and under admitted)

Number of times you have watched the movie :

☐☐☐☐☐☐☐☐☐

☐☐☐☐☐☐☐☐☐

MOVIE TITLE :

..

Director :	Seen for the first time on the :
..	..

Duration : h min

Genre :

- ☐ Animation
- ☐ Adventure
- ☐ Mystery
- ☐ Heroïc fantasy
- ☐ Comedy
- ☐ Action
- ☐ War
- ☐ Science fiction
- ☐ Horror
- ☐ Thriller
- ☐ Drama
- ☐ Epics / Historical
- ☐ Disaster
- ☐ Romance
- ☐ Other :

Seen :

- ☐ on TV
- ☐ in a theatre
- ☐ on DVD
- ☐ on bluray
- ☐ on VOD
- ☐ in a place

Star n°1 :

..

Star n°2 :

..

Music by :

..

Movie released on :

..

Studio :

..

Gauges :

Action Humor Emotion Thrill

Enjoyment :

☆ ☆ ☆ ☆ ☆

Stick here your movie ticket or the synopsis you have printed or cut in a TV magazine :

My favorite scene :

..

..

..

..

..

..

My favorite replica :

..

..

..

..

..

..

Rating :

☐ G (General Audiences)
☐ PG (Parental Guidance Suggested)
☐ PG-13 (Parents Strongly Cautioned)
☐ R (Restricted)
☐ NC-17 (No One 17 and under admitted)

Number of times you have watched the movie :

☐☐☐☐☐☐☐☐☐

☐☐☐☐☐☐☐☐☐

MOVIE TITLE :

..

Director :	Seen for the first time on the :
..	..

Duration : h min	Star n°1 :
Genre :	..
	Star n°2 :
☐ Animation	
☐ Adventure	..
☐ Mystery	Music by :
☐ Heroïc fantasy	
☐ Comedy	..
☐ Action	Movie released on :
☐ War	
☐ Science fiction	..
☐ Horror	Studio :
☐ Thriller	
☐ Drama	..
☐ Epics / Historical	Gauges :
☐ Disaster	
☐ Romance	Action Humor Emotion Thrill
☐ Other :	
Seen :	
☐ on TV	
☐ in a theatre	
☐ on DVD	Enjoyment :
☐ on bluray	
☐ on VOD	☆ ☆ ☆ ☆ ☆
☐ in a place	

Stick here your movie ticket or the synopsis you have printed or cut in a TV magazine :

My favorite scene :

..
..
..
..
..
..

My favorite replica :

..
..
..
..
..
..

Rating :

☐ G (General Audiences)
☐ PG (Parental Guidance Suggested)
☐ PG-13 (Parents Strongly Cautioned)
☐ R (Restricted)
☐ NC-17 (No One 17 and under admitted)

Number of times you have watched the movie :

☐☐☐☐☐☐☐☐☐☐

☐☐☐☐☐☐☐☐☐☐

MOVIE TITLE :

..

Director :	Seen for the first time on the :
..	..

Duration : h min Genre : ☐ Animation ☐ Adventure ☐ Mystery ☐ Heroïc fantasy ☐ Comedy ☐ Action ☐ War ☐ Science fiction ☐ Horror ☐ Thriller ☐ Drama ☐ Epics / Historical ☐ Disaster ☐ Romance ☐ Other : Seen : ☐ on TV ☐ in a theatre ☐ on DVD ☐ on bluray ☐ on VOD ☐ in a place	Star n°1 : .. Star n°2 : .. Music by : .. Movie released on : .. Studio : .. Gauges : Action Humor Emotion Thrill Enjoyment : ☆ ☆ ☆ ☆ ☆

38

Stick here your movie ticket or the synopsis you have printed or cut in a TV magazine :

My favorite scene :

..

..

..

..

..

..

My favorite replica :

..

..

..

..

..

..

Rating :

☐ G (General Audiences)
☐ PG (Parental Guidance Suggested)
☐ PG-13 (Parents Strongly Cautioned)
☐ R (Restricted)
☐ NC-17 (No One 17 and under admitted)

Number of times you have watched the movie :

☐ ☐ ☐ ☐ ☐ ☐ ☐ ☐ ☐

☐ ☐ ☐ ☐ ☐ ☐ ☐ ☐ ☐

MOVIE TITLE :

..

Director :	Seen for the first time on the :
..	..

Duration : h min

Genre :

- ☐ Animation
- ☐ Adventure
- ☐ Mystery
- ☐ Heroïc fantasy
- ☐ Comedy
- ☐ Action
- ☐ War
- ☐ Science fiction
- ☐ Horror
- ☐ Thriller
- ☐ Drama
- ☐ Epics / Historical
- ☐ Disaster
- ☐ Romance
- ☐ Other :

Seen :

- ☐ on TV
- ☐ in a theatre
- ☐ on DVD
- ☐ on bluray
- ☐ on VOD
- ☐ in a place

Star n°1 :

..

Star n°2 :

..

Music by :

..

Movie released on :

..

Studio :

..

Gauges :

Action Humor Emotion Thrill

Enjoyment :

☆ ☆ ☆ ☆ ☆

Stick here your movie ticket or the synopsis you have printed or cut in a TV magazine :

My favorite scene :

...

...

...

...

...

...

My favorite replica :

...

...

...

...

...

...

Rating :

☐ G (General Audiences)
☐ PG (Parental Guidance Suggested)
☐ PG-13 (Parents Strongly Cautioned)
☐ R (Restricted)
☐ NC-17 (No One 17 and under admitted)

Number of times you have watched the movie :

☐☐☐☐☐☐☐☐☐

☐☐☐☐☐☐☐☐☐

MOVIE TITLE :

..

Director :	Seen for the first time on the :
..	..

Duration : h min

Genre :

- ☐ Animation
- ☐ Adventure
- ☐ Mystery
- ☐ Heroïc fantasy
- ☐ Comedy
- ☐ Action
- ☐ War
- ☐ Science fiction
- ☐ Horror
- ☐ Thriller
- ☐ Drama
- ☐ Epics / Historical
- ☐ Disaster
- ☐ Romance
- ☐ Other :

Seen :

- ☐ on TV
- ☐ in a theatre
- ☐ on DVD
- ☐ on bluray
- ☐ on VOD
- ☐ in a place

Star n°1 :

..

Star n°2 :

..

Music by :

..

Movie released on :

..

Studio :

..

Gauges :

Action Humor Emotion Thrill

Enjoyment :

☆ ☆ ☆ ☆ ☆

Stick here your movie ticket or the synopsis you have printed or cut in a TV magazine :

My favorite scene :

..

..

..

..

..

..

My favorite replica :

..

..

..

..

..

..

Rating :

☐ G (General Audiences)
☐ PG (Parental Guidance Suggested)
☐ PG-13 (Parents Strongly Cautioned)
☐ R (Restricted)
☐ NC-17 (No One 17 and under admitted)

Number of times you have watched the movie :

☐☐☐☐☐☐☐☐☐

☐☐☐☐☐☐☐☐☐

MOVIE TITLE :

..

Director :	Seen for the first time on the :
..	..

Duration : h min

Genre :

- ☐ Animation
- ☐ Adventure
- ☐ Mystery
- ☐ Heroïc fantasy
- ☐ Comedy
- ☐ Action
- ☐ War
- ☐ Science fiction
- ☐ Horror
- ☐ Thriller
- ☐ Drama
- ☐ Epics / Historical
- ☐ Disaster
- ☐ Romance
- ☐ Other :

Seen :

- ☐ on TV
- ☐ in a theatre
- ☐ on DVD
- ☐ on bluray
- ☐ on VOD
- ☐ in a place

Star n°1 :

..

Star n°2 :

..

Music by :

..

Movie released on :

..

Studio :

..

Gauges :

Action Humor Emotion Thrill

Enjoyment :

☆ ☆ ☆ ☆ ☆

Stick here your movie ticket or the synopsis you have printed or cut in a TV magazine :

My favorite scene :

..

..

..

..

..

..

My favorite replica :

..

..

..

..

..

..

Rating :

☐ G (General Audiences)
☐ PG (Parental Guidance Suggested)
☐ PG-13 (Parents Strongly Cautioned)
☐ R (Restricted)
☐ NC-17 (No One 17 and under admitted)

Number of times you have watched the movie :

☐ ☐ ☐ ☐ ☐ ☐ ☐ ☐ ☐

☐ ☐ ☐ ☐ ☐ ☐ ☐ ☐ ☐

MOVIE TITLE :

..

Director :	Seen for the first time on the :
..	..

Duration : h min

Genre :

☐ Animation
☐ Adventure
☐ Mystery
☐ Heroïc fantasy
☐ Comedy
☐ Action
☐ War
☐ Science fiction
☐ Horror
☐ Thriller
☐ Drama
☐ Epics / Historical
☐ Disaster
☐ Romance
☐ Other :

Seen :

☐ on TV
☐ in a theatre
☐ on DVD
☐ on bluray
☐ on VOD
☐ in a place

Star n°1 :

..

Star n°2 :

..

Music by :

..

Movie released on :

..

Studio :

..

Gauges :

Action Humor Emotion Thrill

Enjoyment :

☆ ☆ ☆ ☆ ☆

Stick here your movie ticket or the synopsis you have printed or cut in a TV magazine :

My favorite scene :

..

..

..

..

..

..

My favorite replica :

..

..

..

..

..

..

Rating :

☐ G (General Audiences)
☐ PG (Parental Guidance Suggested)
☐ PG-13 (Parents Strongly Cautioned)
☐ R (Restricted)
☐ NC-17 (No One 17 and under admitted)

Number of times you have watched the movie :

☐ ☐ ☐ ☐ ☐ ☐ ☐ ☐ ☐

☐ ☐ ☐ ☐ ☐ ☐ ☐ ☐ ☐

MOVIE TITLE :

..

Director :	Seen for the first time on the :
..	..

Duration : h min

Genre :

- ☐ Animation
- ☐ Adventure
- ☐ Mystery
- ☐ Heroïc fantasy
- ☐ Comedy
- ☐ Action
- ☐ War
- ☐ Science fiction
- ☐ Horror
- ☐ Thriller
- ☐ Drama
- ☐ Epics / Historical
- ☐ Disaster
- ☐ Romance
- ☐ Other :

Seen :

- ☐ on TV
- ☐ in a theatre
- ☐ on DVD
- ☐ on bluray
- ☐ on VOD
- ☐ in a place

Star n°1 :

..

Star n°2 :

..

Music by :

..

Movie released on :

..

Studio :

..

Gauges :

Action Humor Emotion Thrill

Enjoyment :

☆ ☆ ☆ ☆ ☆

Stick here your movie ticket or the synopsis you have printed or cut in a TV magazine :

My favorite scene :

..

..

..

..

..

..

My favorite replica :

..

..

..

..

..

..

Rating :

☐ G (General Audiences)
☐ PG (Parental Guidance Suggested)
☐ PG-13 (Parents Strongly Cautioned)
☐ R (Restricted)
☐ NC-17 (No One 17 and under admitted)

Number of times you have watched the movie :

☐ ☐ ☐ ☐ ☐ ☐ ☐ ☐ ☐

☐ ☐ ☐ ☐ ☐ ☐ ☐ ☐ ☐

MOVIE TITLE :

..

Director :	Seen for the first time on the :
....................................

Duration : h min

Genre :

- ☐ Animation
- ☐ Adventure
- ☐ Mystery
- ☐ Heroïc fantasy
- ☐ Comedy
- ☐ Action
- ☐ War
- ☐ Science fiction
- ☐ Horror
- ☐ Thriller
- ☐ Drama
- ☐ Epics / Historical
- ☐ Disaster
- ☐ Romance
- ☐ Other :

Seen :

- ☐ on TV
- ☐ in a theatre
- ☐ on DVD
- ☐ on bluray
- ☐ on VOD
- ☐ in a place

Star n°1 :

..

Star n°2 :

..

Music by :

..

Movie released on :

..

Studio :

..

Gauges :

Action Humor Emotion Thrill

Enjoyment :

☆ ☆ ☆ ☆ ☆

Stick here your movie ticket or the synopsis you have printed or cut in a TV magazine :

My favorite scene :

..
..
..
..
..
..

My favorite replica :

..
..
..
..
..
..

Rating :

☐ G (General Audiences)
☐ PG (Parental Guidance Suggested)
☐ PG-13 (Parents Strongly Cautioned)
☐ R (Restricted)
☐ NC-17 (No One 17 and under admitted)

Number of times you have watched the movie :

☐ ☐ ☐ ☐ ☐ ☐ ☐ ☐ ☐

☐ ☐ ☐ ☐ ☐ ☐ ☐ ☐ ☐

MOVIE TITLE :

..

Director :	Seen for the first time on the :
..	..

Duration : h min

Genre :

- ☐ Animation
- ☐ Adventure
- ☐ Mystery
- ☐ Heroïc fantasy
- ☐ Comedy
- ☐ Action
- ☐ War
- ☐ Science fiction
- ☐ Horror
- ☐ Thriller
- ☐ Drama
- ☐ Epics / Historical
- ☐ Disaster
- ☐ Romance
- ☐ Other : ...

Seen :

- ☐ on TV
- ☐ in a theatre
- ☐ on DVD
- ☐ on bluray
- ☐ on VOD
- ☐ in a place

Star n°1 :

..

Star n°2 :

..

Music by :

..

Movie released on :

..

Studio :

..

Gauges :

Action Humor Emotion Thrill

Enjoyment :

☆ ☆ ☆ ☆ ☆

Stick here your movie ticket or the synopsis you have printed or cut in a TV magazine :

My favorite scene :

..
..
..
..
..
..

My favorite replica :

..
..
..
..
..
..

Rating :

☐ G (General Audiences)
☐ PG (Parental Guidance Suggested)
☐ PG-13 (Parents Strongly Cautioned)
☐ R (Restricted)
☐ NC-17 (No One 17 and under admitted)

Number of times you have watched the movie :

☐ ☐ ☐ ☐ ☐ ☐ ☐ ☐ ☐

☐ ☐ ☐ ☐ ☐ ☐ ☐ ☐ ☐

MOVIE TITLE :

..

Director :	Seen for the first time on the :
..	..

Duration : h min

Genre :

- ☐ Animation
- ☐ Adventure
- ☐ Mystery
- ☐ Heroïc fantasy
- ☐ Comedy
- ☐ Action
- ☐ War
- ☐ Science fiction
- ☐ Horror
- ☐ Thriller
- ☐ Drama
- ☐ Epics / Historical
- ☐ Disaster
- ☐ Romance
- ☐ Other :

Seen :

- ☐ on TV
- ☐ in a theatre
- ☐ on DVD
- ☐ on bluray
- ☐ on VOD
- ☐ in a place

Star n°1 :

..

Star n°2 :

..

Music by :

..

Movie released on :

..

Studio :

..

Gauges :

Action Humor Emotion Thrill

Enjoyment :

☆ ☆ ☆ ☆ ☆

Stick here your movie ticket or the synopsis you have printed or cut in a TV magazine :

My favorite scene :

..

..

..

..

..

..

My favorite replica :

..

..

..

..

..

..

Rating :

☐ G (General Audiences)
☐ PG (Parental Guidance Suggested)
☐ PG-13 (Parents Strongly Cautioned)
☐ R (Restricted)
☐ NC-17 (No One 17 and under admitted)

Number of times you have watched the movie :

☐ ☐ ☐ ☐ ☐ ☐ ☐ ☐ ☐

☐ ☐ ☐ ☐ ☐ ☐ ☐ ☐ ☐

MOVIE TITLE :

..

Director :	Seen for the first time on the :
..	..

Duration : h min Genre : ☐ Animation ☐ Adventure ☐ Mystery ☐ Heroïc fantasy ☐ Comedy ☐ Action ☐ War ☐ Science fiction ☐ Horror ☐ Thriller ☐ Drama ☐ Epics / Historical ☐ Disaster ☐ Romance ☐ Other : Seen : ☐ on TV ☐ in a theatre ☐ on DVD ☐ on bluray ☐ on VOD ☐ in a place	Star n°1 : .. Star n°2 : .. Music by : .. Movie released on : .. Studio : .. Gauges : Action Humor Emotion Thrill Enjoyment : ☆ ☆ ☆ ☆ ☆

Stick here your movie ticket or the synopsis you have printed or cut in a TV magazine :

My favorite scene :

..

..

..

..

..

..

My favorite replica :

..

..

..

..

..

..

Rating :

☐ G (General Audiences)
☐ PG (Parental Guidance Suggested)
☐ PG-13 (Parents Strongly Cautioned)
☐ R (Restricted)
☐ NC-17 (No One 17 and under admitted)

Number of times you have watched the movie :

☐ ☐ ☐ ☐ ☐ ☐ ☐ ☐ ☐

☐ ☐ ☐ ☐ ☐ ☐ ☐ ☐ ☐

MOVIE TITLE :

..

Director :	Seen for the first time on the :
....................................

Duration : h min

Genre :

- ☐ Animation
- ☐ Adventure
- ☐ Mystery
- ☐ Heroïc fantasy
- ☐ Comedy
- ☐ Action
- ☐ War
- ☐ Science fiction
- ☐ Horror
- ☐ Thriller
- ☐ Drama
- ☐ Epics / Historical
- ☐ Disaster
- ☐ Romance
- ☐ Other :

Seen :

- ☐ on TV
- ☐ in a theatre
- ☐ on DVD
- ☐ on bluray
- ☐ on VOD
- ☐ in a place

Star n°1 :

..

Star n°2 :

..

Music by :

..

Movie released on :

..

Studio :

..

Gauges :

Action	Humor	Emotion	Thrill

Enjoyment :

☆ ☆ ☆ ☆ ☆

58

Stick here your movie ticket or the synopsis you have printed or cut in a TV magazine :

My favorite scene :

..

..

..

..

..

..

My favorite replica :

..

..

..

..

..

..

Rating :

☐ G (General Audiences)
☐ PG (Parental Guidance Suggested)
☐ PG-13 (Parents Strongly Cautioned)
☐ R (Restricted)
☐ NC-17 (No One 17 and under admitted)

Number of times you have watched the movie :

☐☐☐☐☐☐☐☐☐

☐☐☐☐☐☐☐☐☐

MOVIE TITLE :

..

Director :	Seen for the first time on the :
..	..

Duration : h min

Genre :

- ☐ Animation
- ☐ Adventure
- ☐ Mystery
- ☐ Heroïc fantasy
- ☐ Comedy
- ☐ Action
- ☐ War
- ☐ Science fiction
- ☐ Horror
- ☐ Thriller
- ☐ Drama
- ☐ Epics / Historical
- ☐ Disaster
- ☐ Romance
- ☐ Other :

Seen :

- ☐ on TV
- ☐ in a theatre
- ☐ on DVD
- ☐ on bluray
- ☐ on VOD
- ☐ in a place

Star n°1 :

..

Star n°2 :

..

Music by :

..

Movie released on :

..

Studio :

..

Gauges :

Action Humor Emotion Thrill

Enjoyment :

☆ ☆ ☆ ☆ ☆

Stick here your movie ticket or the synopsis you have printed or cut in a TV magazine :

My favorite scene :

..

..

..

..

..

..

My favorite replica :

..

..

..

..

..

..

Rating :

☐ G (General Audiences)
☐ PG (Parental Guidance Suggested)
☐ PG-13 (Parents Strongly Cautioned)
☐ R (Restricted)
☐ NC-17 (No One 17 and under admitted)

Number of times you have watched the movie :

☐☐☐☐☐☐☐☐☐

☐☐☐☐☐☐☐☐☐

MOVIE TITLE :

..

Director :	Seen for the first time on the :
..	..

Duration : h min

Genre :

- ☐ Animation
- ☐ Adventure
- ☐ Mystery
- ☐ Heroïc fantasy
- ☐ Comedy
- ☐ Action
- ☐ War
- ☐ Science fiction
- ☐ Horror
- ☐ Thriller
- ☐ Drama
- ☐ Epics / Historical
- ☐ Disaster
- ☐ Romance
- ☐ Other : ...

Seen :

- ☐ on TV
- ☐ in a theatre
- ☐ on DVD
- ☐ on bluray
- ☐ on VOD
- ☐ in a place

Star n°1 :

..

Star n°2 :

..

Music by :

..

Movie released on :

..

Studio :

..

Gauges :

Action Humor Emotion Thrill

Enjoyment :

☆ ☆ ☆ ☆ ☆

Stick here your movie ticket or the synopsis you have printed or cut in a TV magazine :

My favorite scene :

..

..

..

..

..

..

My favorite replica :

..

..

..

..

..

..

Rating :

☐ G (General Audiences)
☐ PG (Parental Guidance Suggested)
☐ PG-13 (Parents Strongly Cautioned)
☐ R (Restricted)
☐ NC-17 (No One 17 and under admitted)

Number of times you have watched the movie :

☐ ☐ ☐ ☐ ☐ ☐ ☐ ☐ ☐

☐ ☐ ☐ ☐ ☐ ☐ ☐ ☐ ☐

MOVIE TITLE :
..

Director : ..	Seen for the first time on the : ..
Duration : h min Genre : ☐ Animation ☐ Adventure ☐ Mystery ☐ Heroïc fantasy ☐ Comedy ☐ Action ☐ War ☐ Science fiction ☐ Horror ☐ Thriller ☐ Drama ☐ Epics / Historical ☐ Disaster ☐ Romance ☐ Other : Seen : ☐ on TV ☐ in a theatre ☐ on DVD ☐ on bluray ☐ on VOD ☐ in a place	Star n°1 : .. Star n°2 : .. Music by : .. Movie released on : .. Studio : .. Gauges : Action Humor Emotion Thrill Enjoyment : ☆ ☆ ☆ ☆ ☆

Stick here your movie ticket or the synopsis you have printed or cut in a TV magazine :

My favorite scene :

..

..

..

..

..

..

My favorite replica :

..

..

..

..

..

..

Rating :

☐ G (General Audiences)
☐ PG (Parental Guidance Suggested)
☐ PG-13 (Parents Strongly Cautioned)
☐ R (Restricted)
☐ NC-17 (No One 17 and under admitted)

Number of times you have watched the movie :

☐ ☐ ☐ ☐ ☐ ☐ ☐ ☐ ☐

☐ ☐ ☐ ☐ ☐ ☐ ☐ ☐ ☐

MOVIE TITLE :

..

Director :	Seen for the first time on the :
..	..

Duration : h min

Genre :

- ☐ Animation
- ☐ Adventure
- ☐ Mystery
- ☐ Heroïc fantasy
- ☐ Comedy
- ☐ Action
- ☐ War
- ☐ Science fiction
- ☐ Horror
- ☐ Thriller
- ☐ Drama
- ☐ Epics / Historical
- ☐ Disaster
- ☐ Romance
- ☐ Other : ..

Seen :

- ☐ on TV
- ☐ in a theatre
- ☐ on DVD
- ☐ on bluray
- ☐ on VOD
- ☐ in a place

Star n°1 :

..

Star n°2 :

..

Music by :

..

Movie released on :

..

Studio :

..

Gauges :

Action Humor Emotion Thrill

Enjoyment :

☆ ☆ ☆ ☆ ☆

Stick here your movie ticket or the synopsis you have printed or cut in a TV magazine :

My favorite scene :

..

..

..

..

..

..

My favorite replica :

..

..

..

..

..

..

Rating :

☐ G (General Audiences)
☐ PG (Parental Guidance Suggested)
☐ PG-13 (Parents Strongly Cautioned)
☐ R (Restricted)
☐ NC-17 (No One 17 and under admitted)

Number of times you have watched the movie :

☐☐☐☐☐☐☐☐☐☐

☐☐☐☐☐☐☐☐☐☐

MOVIE TITLE :

..

Director :	Seen for the first time on the :
..	..

Duration : h min

Genre :

- ☐ Animation
- ☐ Adventure
- ☐ Mystery
- ☐ Heroïc fantasy
- ☐ Comedy
- ☐ Action
- ☐ War
- ☐ Science fiction
- ☐ Horror
- ☐ Thriller
- ☐ Drama
- ☐ Epics / Historical
- ☐ Disaster
- ☐ Romance
- ☐ Other : ...

Seen :

- ☐ on TV
- ☐ in a theatre
- ☐ on DVD
- ☐ on bluray
- ☐ on VOD
- ☐ in a place

Star n°1 :

..

Star n°2 :

..

Music by :

..

Movie released on :

..

Studio :

..

Gauges :

Action Humor Emotion Thrill

Enjoyment :

☆ ☆ ☆ ☆ ☆

Stick here your movie ticket or the synopsis you have printed or cut in a TV magazine :

My favorite scene :

..

..

..

..

..

..

My favorite replica :

..

..

..

..

..

..

Rating :

☐ G (General Audiences)
☐ PG (Parental Guidance Suggested)
☐ PG-13 (Parents Strongly Cautioned)
☐ R (Restricted)
☐ NC-17 (No One 17 and under admitted)

Number of times you have watched the movie :

☐ ☐ ☐ ☐ ☐ ☐ ☐ ☐ ☐

☐ ☐ ☐ ☐ ☐ ☐ ☐ ☐ ☐

MOVIE TITLE :

..

Director :	Seen for the first time on the :
..	..

Duration : h min

Genre :

☐ Animation
☐ Adventure
☐ Mystery
☐ Heroïc fantasy
☐ Comedy
☐ Action
☐ War
☐ Science fiction
☐ Horror
☐ Thriller
☐ Drama
☐ Epics / Historical
☐ Disaster
☐ Romance
☐ Other :

Seen :

☐ on TV
☐ in a theatre
☐ on DVD
☐ on bluray
☐ on VOD
☐ in a place

Star n°1 :

..

Star n°2 :

..

Music by :

..

Movie released on :

..

Studio :

..

Gauges :

Action Humor Emotion Thrill

Enjoyment :

☆ ☆ ☆ ☆ ☆

Stick here your movie ticket or the synopsis you have printed or cut in a TV magazine :

My favorite scene :

..
..
..
..
..
..

My favorite replica :

..
..
..
..
..
..

Rating :

☐ G (General Audiences)
☐ PG (Parental Guidance Suggested)
☐ PG-13 (Parents Strongly Cautioned)
☐ R (Restricted)
☐ NC-17 (No One 17 and under admitted)

Number of times you have watched the movie :

☐ ☐ ☐ ☐ ☐ ☐ ☐ ☐ ☐

☐ ☐ ☐ ☐ ☐ ☐ ☐ ☐ ☐

MOVIE TITLE :

..

Director :	Seen for the first time on the :
..	..

Duration : h min

Genre :

- ☐ Animation
- ☐ Adventure
- ☐ Mystery
- ☐ Heroïc fantasy
- ☐ Comedy
- ☐ Action
- ☐ War
- ☐ Science fiction
- ☐ Horror
- ☐ Thriller
- ☐ Drama
- ☐ Epics / Historical
- ☐ Disaster
- ☐ Romance
- ☐ Other :

Seen :

- ☐ on TV
- ☐ in a theatre
- ☐ on DVD
- ☐ on bluray
- ☐ on VOD
- ☐ in a place

Star n°1 :

..

Star n°2 :

..

Music by :

..

Movie released on :

..

Studio :

..

Gauges :

Action Humor Emotion Thrill

Enjoyment :

☆ ☆ ☆ ☆ ☆

Stick here your movie ticket or the synopsis you have printed or cut in a TV magazine :

My favorite scene :

..
..
..
..
..
..

My favorite replica :

..
..
..
..
..
..

Rating :

☐ G (General Audiences)
☐ PG (Parental Guidance Suggested)
☐ PG-13 (Parents Strongly Cautioned)
☐ R (Restricted)
☐ NC-17 (No One 17 and under admitted)

Number of times you have watched the movie :

☐ ☐ ☐ ☐ ☐ ☐ ☐ ☐ ☐

☐ ☐ ☐ ☐ ☐ ☐ ☐ ☐ ☐

MOVIE TITLE :

..

Director :	Seen for the first time on the :
..	..

Duration : h min Genre : ☐ Animation ☐ Adventure ☐ Mystery ☐ Heroïc fantasy ☐ Comedy ☐ Action ☐ War ☐ Science fiction ☐ Horror ☐ Thriller ☐ Drama ☐ Epics / Historical ☐ Disaster ☐ Romance ☐ Other : Seen : ☐ on TV ☐ in a theatre ☐ on DVD ☐ on bluray ☐ on VOD ☐ in a place	Star n°1 : .. Star n°2 : .. Music by : .. Movie released on : .. Studio : .. Gauges : Action Humor Emotion Thrill Enjoyment : ☆ ☆ ☆ ☆ ☆

Stick here your movie ticket or the synopsis you have printed or cut in a TV magazine :

My favorite scene :

..

..

..

..

..

..

My favorite replica :

..

..

..

..

..

..

Rating :

☐ G (General Audiences)
☐ PG (Parental Guidance Suggested)
☐ PG-13 (Parents Strongly Cautioned)
☐ R (Restricted)
☐ NC-17 (No One 17 and under admitted)

Number of times you have watched the movie :

☐ ☐ ☐ ☐ ☐ ☐ ☐ ☐ ☐

☐ ☐ ☐ ☐ ☐ ☐ ☐ ☐ ☐

MOVIE TITLE :

..

Director :	Seen for the first time on the :
..	..

Duration : h min

Genre :

☐ Animation
☐ Adventure
☐ Mystery
☐ Heroïc fantasy
☐ Comedy
☐ Action
☐ War
☐ Science fiction
☐ Horror
☐ Thriller
☐ Drama
☐ Epics / Historical
☐ Disaster
☐ Romance
☐ Other :

Seen :

☐ on TV
☐ in a theatre
☐ on DVD
☐ on bluray
☐ on VOD
☐ in a place

Star n°1 :

..

Star n°2 :

..

Music by :

..

Movie released on :

..

Studio :

..

Gauges :

Action Humor Emotion Thrill

Enjoyment :

☆ ☆ ☆ ☆ ☆

Stick here your movie ticket or the synopsis you have printed or cut in a TV magazine :

My favorite scene :

..

..

..

..

..

..

My favorite replica :

..

..

..

..

..

..

Rating :

☐ G (General Audiences)
☐ PG (Parental Guidance Suggested)
☐ PG-13 (Parents Strongly Cautioned)
☐ R (Restricted)
☐ NC-17 (No One 17 and under admitted)

Number of times you have watched the movie :

☐ ☐ ☐ ☐ ☐ ☐ ☐ ☐ ☐

☐ ☐ ☐ ☐ ☐ ☐ ☐ ☐ ☐

MOVIE TITLE :

..

Director :	Seen for the first time on the :
..	..

Duration : h min

Genre :

- ☐ Animation
- ☐ Adventure
- ☐ Mystery
- ☐ Heroïc fantasy
- ☐ Comedy
- ☐ Action
- ☐ War
- ☐ Science fiction
- ☐ Horror
- ☐ Thriller
- ☐ Drama
- ☐ Epics / Historical
- ☐ Disaster
- ☐ Romance
- ☐ Other :

Seen :

- ☐ on TV
- ☐ in a theatre
- ☐ on DVD
- ☐ on bluray
- ☐ on VOD
- ☐ in a place

Star n°1 :

..

Star n°2 :

..

Music by :

..

Movie released on :

..

Studio :

..

Gauges :

Action Humor Emotion Thrill

Enjoyment :

☆ ☆ ☆ ☆ ☆

Stick here your movie ticket or the synopsis you have printed or cut in a TV magazine :

My favorite scene :

...
...
...
...
...
...

My favorite replica :

...
...
...
...
...
...

Rating :

☐ G (General Audiences)
☐ PG (Parental Guidance Suggested)
☐ PG-13 (Parents Strongly Cautioned)
☐ R (Restricted)
☐ NC-17 (No One 17 and under admitted)

Number of times you have watched the movie :

☐ ☐ ☐ ☐ ☐ ☐ ☐ ☐ ☐

☐ ☐ ☐ ☐ ☐ ☐ ☐ ☐ ☐

MOVIE TITLE :

..

Director :	Seen for the first time on the :
..	..

Duration : h min

Genre :

- ☐ Animation
- ☐ Adventure
- ☐ Mystery
- ☐ Heroïc fantasy
- ☐ Comedy
- ☐ Action
- ☐ War
- ☐ Science fiction
- ☐ Horror
- ☐ Thriller
- ☐ Drama
- ☐ Epics / Historical
- ☐ Disaster
- ☐ Romance
- ☐ Other :

Seen :

- ☐ on TV
- ☐ in a theatre
- ☐ on DVD
- ☐ on bluray
- ☐ on VOD
- ☐ in a place

Star n°1 :

..

Star n°2 :

..

Music by :

..

Movie released on :

..

Studio :

..

Gauges :

Action Humor Emotion Thrill

Enjoyment :

☆ ☆ ☆ ☆ ☆

Stick here your movie ticket or the synopsis you have printed or cut in a TV magazine :

My favorite scene :

..

..

..

..

..

..

My favorite replica :

..

..

..

..

..

..

Rating :

☐ G (General Audiences)
☐ PG (Parental Guidance Suggested)
☐ PG-13 (Parents Strongly Cautioned)
☐ R (Restricted)
☐ NC-17 (No One 17 and under admitted)

Number of times you have watched the movie :

☐ ☐ ☐ ☐ ☐ ☐ ☐ ☐ ☐

☐ ☐ ☐ ☐ ☐ ☐ ☐ ☐ ☐

MOVIE TITLE :

..

Director :	Seen for the first time on the :
..	..

Duration : h min

Genre :

- ☐ Animation
- ☐ Adventure
- ☐ Mystery
- ☐ Heroïc fantasy
- ☐ Comedy
- ☐ Action
- ☐ War
- ☐ Science fiction
- ☐ Horror
- ☐ Thriller
- ☐ Drama
- ☐ Epics / Historical
- ☐ Disaster
- ☐ Romance
- ☐ Other :

Seen :

- ☐ on TV
- ☐ in a theatre
- ☐ on DVD
- ☐ on bluray
- ☐ on VOD
- ☐ in a place

Star n°1 :

..

Star n°2 :

..

Music by :

..

Movie released on :

..

Studio :

..

Gauges :

Action Humor Emotion Thrill

Enjoyment :

☆ ☆ ☆ ☆ ☆

Stick here your movie ticket or the synopsis you have printed or cut in a TV magazine :

My favorite scene :

..
..
..
..
..
..

My favorite replica :

..
..
..
..
..
..

Rating :

☐ G (General Audiences)
☐ PG (Parental Guidance Suggested)
☐ PG-13 (Parents Strongly Cautioned)
☐ R (Restricted)
☐ NC-17 (No One 17 and under admitted)

Number of times you have watched the movie :

☐☐☐☐☐☐☐☐☐

☐☐☐☐☐☐☐☐☐

MOVIE TITLE :

...

Director :	Seen for the first time on the :
..	..

Duration : h min

Genre :

- ☐ Animation
- ☐ Adventure
- ☐ Mystery
- ☐ Heroïc fantasy
- ☐ Comedy
- ☐ Action
- ☐ War
- ☐ Science fiction
- ☐ Horror
- ☐ Thriller
- ☐ Drama
- ☐ Epics / Historical
- ☐ Disaster
- ☐ Romance
- ☐ Other : ..

Seen :

- ☐ on TV
- ☐ in a theatre
- ☐ on DVD
- ☐ on bluray
- ☐ on VOD
- ☐ in a place

Star n°1 :

..

Star n°2 :

..

Music by :

..

Movie released on :

..

Studio :

..

Gauges :

Action Humor Emotion Thrill

Enjoyment :

☆ ☆ ☆ ☆ ☆

Stick here your movie ticket or the synopsis you have printed or cut in a TV magazine :

My favorite scene :

..

..

..

..

..

..

My favorite replica :

..

..

..

..

..

..

Rating :

☐ G (General Audiences)
☐ PG (Parental Guidance Suggested)
☐ PG-13 (Parents Strongly Cautioned)
☐ R (Restricted)
☐ NC-17 (No One 17 and under admitted)

Number of times you have watched the movie :

☐☐☐☐☐☐☐☐☐

☐☐☐☐☐☐☐☐☐

MOVIE TITLE :

..

Director :	Seen for the first time on the :
..	..

Duration : h min

Genre :

- ☐ Animation
- ☐ Adventure
- ☐ Mystery
- ☐ Heroïc fantasy
- ☐ Comedy
- ☐ Action
- ☐ War
- ☐ Science fiction
- ☐ Horror
- ☐ Thriller
- ☐ Drama
- ☐ Epics / Historical
- ☐ Disaster
- ☐ Romance
- ☐ Other :

Seen :

- ☐ on TV
- ☐ in a theatre
- ☐ on DVD
- ☐ on bluray
- ☐ on VOD
- ☐ in a place

Star n°1 :

..

Star n°2 :

..

Music by :

..

Movie released on :

..

Studio :

..

Gauges :

Action Humor Emotion Thrill

Enjoyment :

☆ ☆ ☆ ☆ ☆

Stick here your movie ticket or the synopsis you have printed or cut in a TV magazine :

My favorite scene :

..

..

..

..

..

..

My favorite replica :

..

..

..

..

..

..

Rating :

☐ G (General Audiences)
☐ PG (Parental Guidance Suggested)
☐ PG-13 (Parents Strongly Cautioned)
☐ R (Restricted)
☐ NC-17 (No One 17 and under admitted)

Number of times you have watched the movie :

☐☐☐☐☐☐☐☐☐

☐☐☐☐☐☐☐☐☐

MOVIE TITLE :

..

Director :	Seen for the first time on the :
..	..

Duration : h min

Genre :

- ☐ Animation
- ☐ Adventure
- ☐ Mystery
- ☐ Heroïc fantasy
- ☐ Comedy
- ☐ Action
- ☐ War
- ☐ Science fiction
- ☐ Horror
- ☐ Thriller
- ☐ Drama
- ☐ Epics / Historical
- ☐ Disaster
- ☐ Romance
- ☐ Other :

Seen :

- ☐ on TV
- ☐ in a theatre
- ☐ on DVD
- ☐ on bluray
- ☐ on VOD
- ☐ in a place

Star n°1 :

..

Star n°2 :

..

Music by :

..

Movie released on :

..

Studio :

..

Gauges :

Action Humor Emotion Thrill

Enjoyment :

☆ ☆ ☆ ☆ ☆

Stick here your movie ticket or the synopsis you have printed or cut in a TV magazine :

My favorite scene :

...

...

...

...

...

...

My favorite replica :

...

...

...

...

...

...

Rating :

☐ G (General Audiences)
☐ PG (Parental Guidance Suggested)
☐ PG-13 (Parents Strongly Cautioned)
☐ R (Restricted)
☐ NC-17 (No One 17 and under admitted)

Number of times you have watched the movie :

☐☐☐☐☐☐☐☐☐

☐☐☐☐☐☐☐☐☐

MOVIE TITLE :

..

Director :	Seen for the first time on the :
..	..

Duration : h min

Genre :

- ☐ Animation
- ☐ Adventure
- ☐ Mystery
- ☐ Heroïc fantasy
- ☐ Comedy
- ☐ Action
- ☐ War
- ☐ Science fiction
- ☐ Horror
- ☐ Thriller
- ☐ Drama
- ☐ Epics / Historical
- ☐ Disaster
- ☐ Romance
- ☐ Other :

Seen :

- ☐ on TV
- ☐ in a theatre
- ☐ on DVD
- ☐ on bluray
- ☐ on VOD
- ☐ in a place

Star n°1 :

..

Star n°2 :

..

Music by :

..

Movie released on :

..

Studio :

..

Gauges :

Action Humor Emotion Thrill

Enjoyment :

☆ ☆ ☆ ☆ ☆

Stick here your movie ticket or the synopsis you have printed or cut in a TV magazine :

My favorite scene :

..

..

..

..

..

..

My favorite replica :

..

..

..

..

..

..

Rating :

☐ G (General Audiences)
☐ PG (Parental Guidance Suggested)
☐ PG-13 (Parents Strongly Cautioned)
☐ R (Restricted)
☐ NC-17 (No One 17 and under admitted)

Number of times you have watched the movie :

☐ ☐ ☐ ☐ ☐ ☐ ☐ ☐ ☐

☐ ☐ ☐ ☐ ☐ ☐ ☐ ☐ ☐

MOVIE TITLE :

..

Director :	Seen for the first time on the :
..	..

Duration : h min

Genre :

- ☐ Animation
- ☐ Adventure
- ☐ Mystery
- ☐ Heroïc fantasy
- ☐ Comedy
- ☐ Action
- ☐ War
- ☐ Science fiction
- ☐ Horror
- ☐ Thriller
- ☐ Drama
- ☐ Epics / Historical
- ☐ Disaster
- ☐ Romance
- ☐ Other : ...

Seen :

- ☐ on TV
- ☐ in a theatre
- ☐ on DVD
- ☐ on bluray
- ☐ on VOD
- ☐ in a place

Star n°1 :

..

Star n°2 :

..

Music by :

..

Movie released on :

..

Studio :

..

Gauges :

Action Humor Emotion Thrill

Enjoyment :

☆ ☆ ☆ ☆ ☆

Stick here your movie ticket or the synopsis you have printed or cut in a TV magazine :

My favorite scene :

..

..

..

..

..

..

My favorite replica :

..

..

..

..

..

..

Rating :

☐ G (General Audiences)
☐ PG (Parental Guidance Suggested)
☐ PG-13 (Parents Strongly Cautioned)
☐ R (Restricted)
☐ NC-17 (No One 17 and under admitted)

Number of times you have watched the movie :

☐ ☐ ☐ ☐ ☐ ☐ ☐ ☐ ☐

☐ ☐ ☐ ☐ ☐ ☐ ☐ ☐ ☐

MOVIE TITLE :

..

Director :	Seen for the first time on the :
..	..

Duration : h min

Genre :

- ☐ Animation
- ☐ Adventure
- ☐ Mystery
- ☐ Heroïc fantasy
- ☐ Comedy
- ☐ Action
- ☐ War
- ☐ Science fiction
- ☐ Horror
- ☐ Thriller
- ☐ Drama
- ☐ Epics / Historical
- ☐ Disaster
- ☐ Romance
- ☐ Other :

Seen :

- ☐ on TV
- ☐ in a theatre
- ☐ on DVD
- ☐ on bluray
- ☐ on VOD
- ☐ in a place

Star n°1 :

..

Star n°2 :

..

Music by :

..

Movie released on :

..

Studio :

..

Gauges :

Action Humor Emotion Thrill

Enjoyment :

☆ ☆ ☆ ☆ ☆

Stick here your movie ticket or the synopsis you have printed or cut in a TV magazine :

My favorite scene :

..

..

..

..

..

..

My favorite replica :

..

..

..

..

..

..

Rating :

☐ G (General Audiences)
☐ PG (Parental Guidance Suggested)
☐ PG-13 (Parents Strongly Cautioned)
☐ R (Restricted)
☐ NC-17 (No One 17 and under admitted)

Number of times you have watched the movie :

☐☐☐☐☐☐☐☐☐

☐☐☐☐☐☐☐☐☐

MOVIE TITLE :

..

Director :	Seen for the first time on the :
..	..

Duration : h min

Genre :

- ☐ Animation
- ☐ Adventure
- ☐ Mystery
- ☐ Heroïc fantasy
- ☐ Comedy
- ☐ Action
- ☐ War
- ☐ Science fiction
- ☐ Horror
- ☐ Thriller
- ☐ Drama
- ☐ Epics / Historical
- ☐ Disaster
- ☐ Romance
- ☐ Other :

Seen :

- ☐ on TV
- ☐ in a theatre
- ☐ on DVD
- ☐ on bluray
- ☐ on VOD
- ☐ in a place

Star n°1 :

..

Star n°2 :

..

Music by :

..

Movie released on :

..

Studio :

..

Gauges :

Action Humor Emotion Thrill

Enjoyment :

☆ ☆ ☆ ☆ ☆

Stick here your movie ticket or the synopsis you have printed or cut in a TV magazine :

My favorite scene :

..

..

..

..

..

..

My favorite replica :

..

..

..

..

..

..

Rating :

☐ G (General Audiences)
☐ PG (Parental Guidance Suggested)
☐ PG-13 (Parents Strongly Cautioned)
☐ R (Restricted)
☐ NC-17 (No One 17 and under admitted)

Number of times you have watched the movie :

☐☐☐☐☐☐☐☐☐

☐☐☐☐☐☐☐☐☐

MOVIE TITLE :

..

Director :	Seen for the first time on the :
..	..

Duration : h min

Genre :

- ☐ Animation
- ☐ Adventure
- ☐ Mystery
- ☐ Heroïc fantasy
- ☐ Comedy
- ☐ Action
- ☐ War
- ☐ Science fiction
- ☐ Horror
- ☐ Thriller
- ☐ Drama
- ☐ Epics / Historical
- ☐ Disaster
- ☐ Romance
- ☐ Other : ..

Seen :

- ☐ on TV
- ☐ in a theatre
- ☐ on DVD
- ☐ on bluray
- ☐ on VOD
- ☐ in a place

Star n°1 :

..

Star n°2 :

..

Music by :

..

Movie released on :

..

Studio :

..

Gauges :

Action Humor Emotion Thrill

Enjoyment :

☆ ☆ ☆ ☆ ☆

Stick here your movie ticket or the synopsis you have printed or cut in a TV magazine :

My favorite scene :

..

..

..

..

..

..

My favorite replica :

..

..

..

..

..

..

Rating :

☐ G (General Audiences)
☐ PG (Parental Guidance Suggested)
☐ PG-13 (Parents Strongly Cautioned)
☐ R (Restricted)
☐ NC-17 (No One 17 and under admitted)

Number of times you have watched the movie :

☐ ☐ ☐ ☐ ☐ ☐ ☐ ☐ ☐

☐ ☐ ☐ ☐ ☐ ☐ ☐ ☐ ☐

MOVIE TITLE :

..

Director :	Seen for the first time on the :
..	..

Duration : h min

Genre :

- ☐ Animation
- ☐ Adventure
- ☐ Mystery
- ☐ Heroïc fantasy
- ☐ Comedy
- ☐ Action
- ☐ War
- ☐ Science fiction
- ☐ Horror
- ☐ Thriller
- ☐ Drama
- ☐ Epics / Historical
- ☐ Disaster
- ☐ Romance
- ☐ Other :

Seen :

- ☐ on TV
- ☐ in a theatre
- ☐ on DVD
- ☐ on bluray
- ☐ on VOD
- ☐ in a place

Star n°1 :
..

Star n°2 :
..

Music by :
..

Movie released on :
..

Studio :
..

Gauges :

Action Humor Emotion Thrill

Enjoyment :

☆ ☆ ☆ ☆ ☆

Stick here your movie ticket or the synopsis you have printed or cut in a TV magazine :

My favorite scene :

..

..

..

..

..

..

My favorite replica :

..

..

..

..

..

..

Rating :

☐ G (General Audiences)
☐ PG (Parental Guidance Suggested)
☐ PG-13 (Parents Strongly Cautioned)
☐ R (Restricted)
☐ NC-17 (No One 17 and under admitted)

Number of times you have watched the movie :

☐☐☐☐☐☐☐☐☐

☐☐☐☐☐☐☐☐☐

MOVIE TITLE :

..

Director :	Seen for the first time on the :
..	..

Duration : h min

Genre :

- ☐ Animation
- ☐ Adventure
- ☐ Mystery
- ☐ Heroïc fantasy
- ☐ Comedy
- ☐ Action
- ☐ War
- ☐ Science fiction
- ☐ Horror
- ☐ Thriller
- ☐ Drama
- ☐ Epics / Historical
- ☐ Disaster
- ☐ Romance
- ☐ Other :

Seen :

- ☐ on TV
- ☐ in a theatre
- ☐ on DVD
- ☐ on bluray
- ☐ on VOD
- ☐ in a place

Star n°1 :

..

Star n°2 :

..

Music by :

..

Movie released on :

..

Studio :

..

Gauges :

Action Humor Emotion Thrill

Enjoyment :

☆ ☆ ☆ ☆ ☆

Stick here your movie ticket or the synopsis you have printed or cut in a TV magazine :

My favorite scene :

..

..

..

..

..

..

My favorite replica :

..

..

..

..

..

..

Rating :

☐ G (General Audiences)
☐ PG (Parental Guidance Suggested)
☐ PG-13 (Parents Strongly Cautioned)
☐ R (Restricted)
☐ NC-17 (No One 17 and under admitted)

Number of times you have watched the movie :

☐☐☐☐☐☐☐☐☐

☐☐☐☐☐☐☐☐☐

Printed by Lulu.com
December 2016
N° ISBN : 978-1-326-90353-4